The Interactive Sketchbook
Black & White Economy Edition
by Eric Gibbons and photographer Dongkui Lin

Copyright 2015
Publisher: Firehouse Publications
 8 Walnut Street, Bordentown, NJ 08505
www.FirehousePublications.com

ISBN-13: 978-1-940290-40-9
ISBN-10: 1940290406

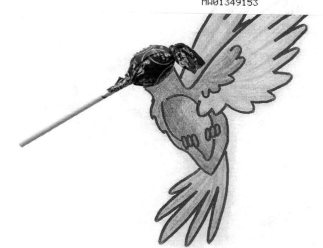

Limited Copyright Agreement: The purchaser of this book, <u>whose name shall appear below</u>, is authorized by their purchase to make copies for the instruction of their students. Should multiple instructors teach from these materials, each instructor must purchase their own copy. This copyright does not extend beyond the individual to a whole department, school, or district. One copy per instructor. **If no name appears below, then the following copyright will be in force:**

No part of this book may be used or reproduced by any means, graphic, electronic, or mechanical, including photocopying, recording, taping or by any information storage retrieval system without the written permission of the author except in the case of brief quotations embodied in critical articles and reviews.

Printed Name of purchaser: _____

Signature of purchaser: _____

Date of Purchase: ___/___/_____

Venue of purchase _____

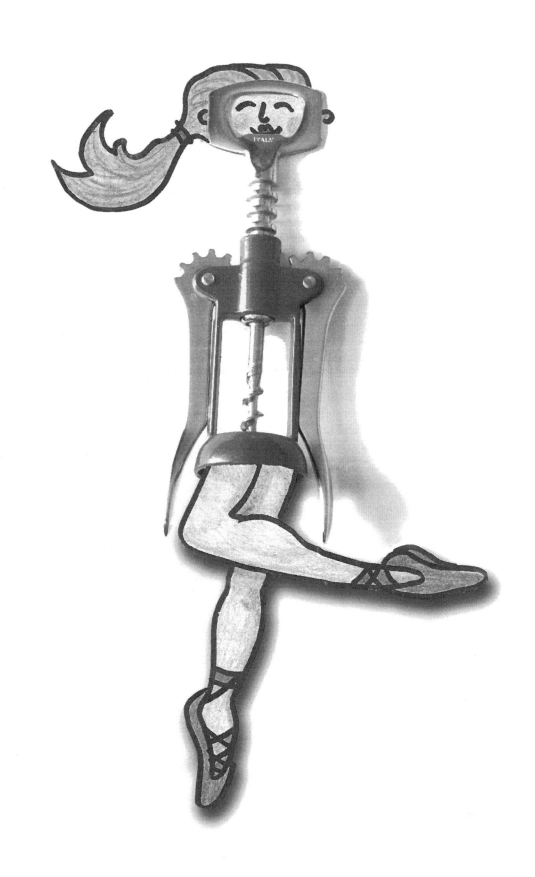

Introduction

Each page has an image to complete in some fun and unexpected way. You can see some wonderful examples of artists who do this today like Christoph Niemann, Tatiana Khlopkova, or Hyemi Jeong.

Feel free to use this book as a sketchbook, turn it in any direction you feel works for your idea. Teachers can cut the spine, and start a bin of images to be completed when students finish regular class work early. This book is available in either full color, or black and white, based on your budget. It is just a starting point and may inspire you to take some photos on white backgrounds yourself and play with the same concept on your own.

Most of the images were taken by photographer Dongkui Lin, and others were taken from the Wikipedia Commons, a great source for copyright free images. We have included those credits in the back of the book, and thank those photographers for making their work broadly available. commons.wikimedia.org

We know that some markers bleed through paper, so we have designed this book with nothing on the back side of each image. For extra protection, put an additional sheet of paper under your drawing, especially if you like to use permanent markers like Sharpie. They can soak through several pages.

Now go have some fun!

Eric Gibbons
www.FirehousePublications.com
www.ArtEdGuru.com

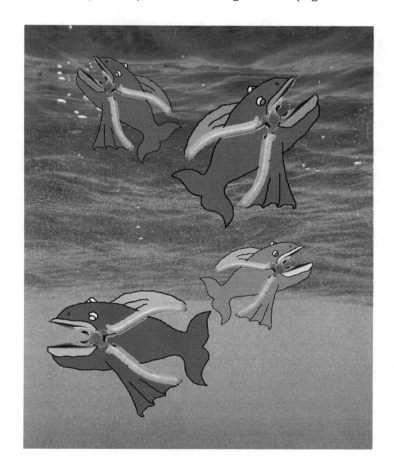

27

The Interactive Sketchbook www.FirehousePublications.com

The Interactive Sketchbook www.FirehousePublications.com

The Interactive Sketchbook www.FirehousePublications.com

The Interactive Sketchbook www.FirehousePublications.com

The Interactive Sketchbook www.FirehousePublications.com

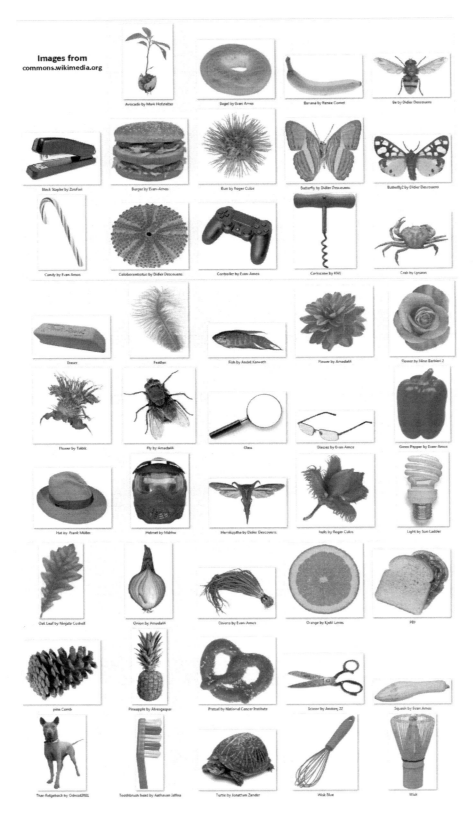

Made in the USA
Middletown, DE
11 September 2015